Terry Harrison's

Watercolour Trees

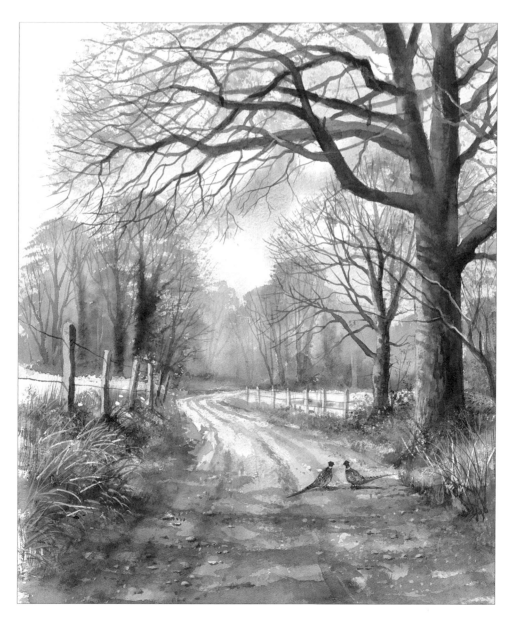

SEARCH PRESS

D1081459

First published in Great Britain 2005

Search Press Limited
Wellwood, North Farm Road,
Tunbridge Wells, Kent TN2 3DR

Text copyright © Terry Harrison 2005

Reprinted 2005, 2006 (Twice), 2007, 2008, 2009

Photographs by Roddy Paine Studios
Photographs and design copyright © Search Press Ltd. 2005

All rights reserved. No part of this book, text, photographs
or illustrations may be reproduced or transmitted in any
form or by any means by print, photoprint, microfilm,
microfiche, photocopier, internet or in any way known
or as yet unknown, or stored in a retrieval system,
without written permission obtained beforehand from
Search Press.

ISBN: 978 1 84448 050 0

The Publishers and author can accept no responsibility for
any consequences arising from the information, advice or
instructions given in this publication.

Suppliers
If you have any difficulty obtaining any of the materials and
equipment mentioned in this book, please contact
Terry Harrison at:

Telephone: +44 (0)1386 584840

Website: www.terryharrisonart.com

Publishers' note
All the step-by-step photographs in this book feature the
author, Terry Harrison, demonstrating how to paint with
watercolours. No models have been used.

Printed in Malaysia

*To my wife Kate
and my daughters
Amy and Lucy*

*I would like to thank my parents for all their love
and encouragement. Without their support I
would possibly have followed a completely
different career! I would also like to thank Kate,
my long suffering wife. Without her support I
would probably still have my old day job.*

Cover
Apple blossom time
510 x 355mm (20 x 14in)
*I discovered this old-fashioned apple orchard while
doing a workshop in a remote Somerset village and
decided to paint it. It was an ideal opportunity to
use masking fluid to achieve a beautiful blossom
effect (see page 38).*

Page 1
Chatting in the lane
380 x 510mm (15 x 20in)
*The dark tree, shadows and bank in the foreground
create a frame, leading the eye into the middle of the
painting. The pheasants provide an additional point
of interest. Notice how the trees fade into the
distance – they are lighter and bluer to create the
feeling of recession.*

Page 3
Winter trees
280 x 510mm (11 x 20in)
*Lighter and darker tones are used to create the
feeling of perspective. The misty background trees
are painted first, then the trees in the middle
distance are added using slightly deeper tones.
Shading and detail are added to the foreground tree,
which is the focal point of the picture.*

Contents

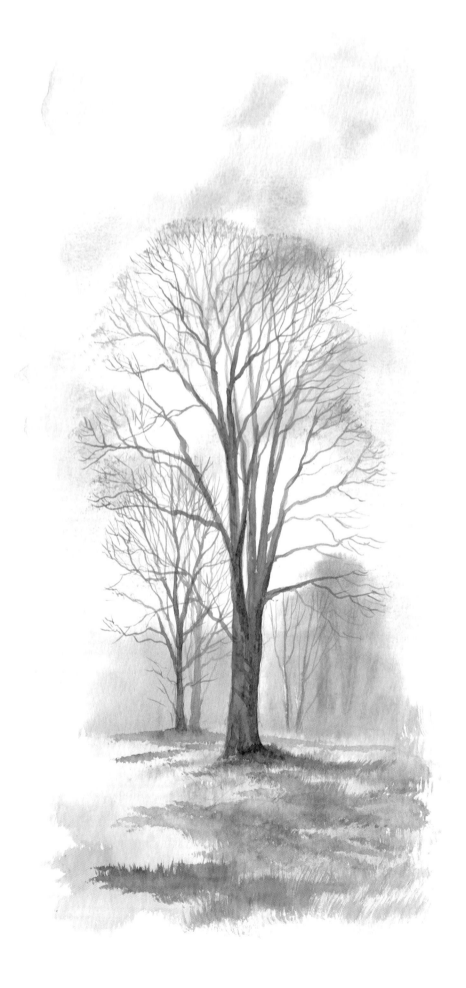

Introduction

Trees are my favourite subject and I love painting them. They are an important part of the landscape and interesting trees can make a big difference to a scene. A twisted, wind-blasted oak or a shimmering grey-green beech can add atmosphere and life to a mediocre view, so I frequently use artistic licence to add a tree to an otherwise bland picture. I prefer to paint an impression rather than slavishly reproduce each detail, but it is still important to learn about the different shapes and the way the foliage changes with the seasons. A good knowledge of a subject is essential if you want to produce believable paintings.

I would advise anyone interested in painting to look at the work of other artists and to understand their methods, then go on to develop a style of their own. When I first started to paint, I was inspired by the artist Rowland Hilder and it gave me the desire and enthusiasm to paint my own pictures. The demonstrations in this book show how easy it is to build up your skills with a few tricks and the right brushes. I have included a section on really easy trees, which will, I hope, give you the confidence to progress through the book before moving on to tackle more detailed impressions. Watercolour is a wonderful medium with translucent qualities. Dry brush, simple washes and wet-into-wet techniques can be used with great effect to capture trunks, branches and foliage, so practise these techniques and you will soon be enjoying the challenge of creating your own paintings.

Wherever I go I take a camera and sketchbook with me. Photographs and sketches are useful and I often refer to them when I am working back in the studio. It is also interesting to revisit the trees at different times of the year. The changing seasons have dramatic effects on deciduous trees, which can be splendid in their summer raiment, stunning in autumn sun, magnificent in their winter habitat or beautiful bedecked in spring foliage.

It is impossible to cover everything in this book. I have managed to include my favourite trees, although I must confess that recognising unusual varieties is not my strong point. I am far more interested in capturing the effect than in relaying botanical accuracy. I am a great fan of botanical gardens and arboretums because trees and plants are usually labelled! So, I apologise in advance if I have identified something wrongly. The important thing is to enjoy the painting, which I am glad to say I still do.

Terry Harrison

Short cut
*430 x 535mm (17 x 21in)
The tree is the dominant feature in this painting, but the stile invites you to travel across the fields and explore the countryside beyond. The foreground grasses are masked out with masking fluid first, then washed over with different tones of green.*

4

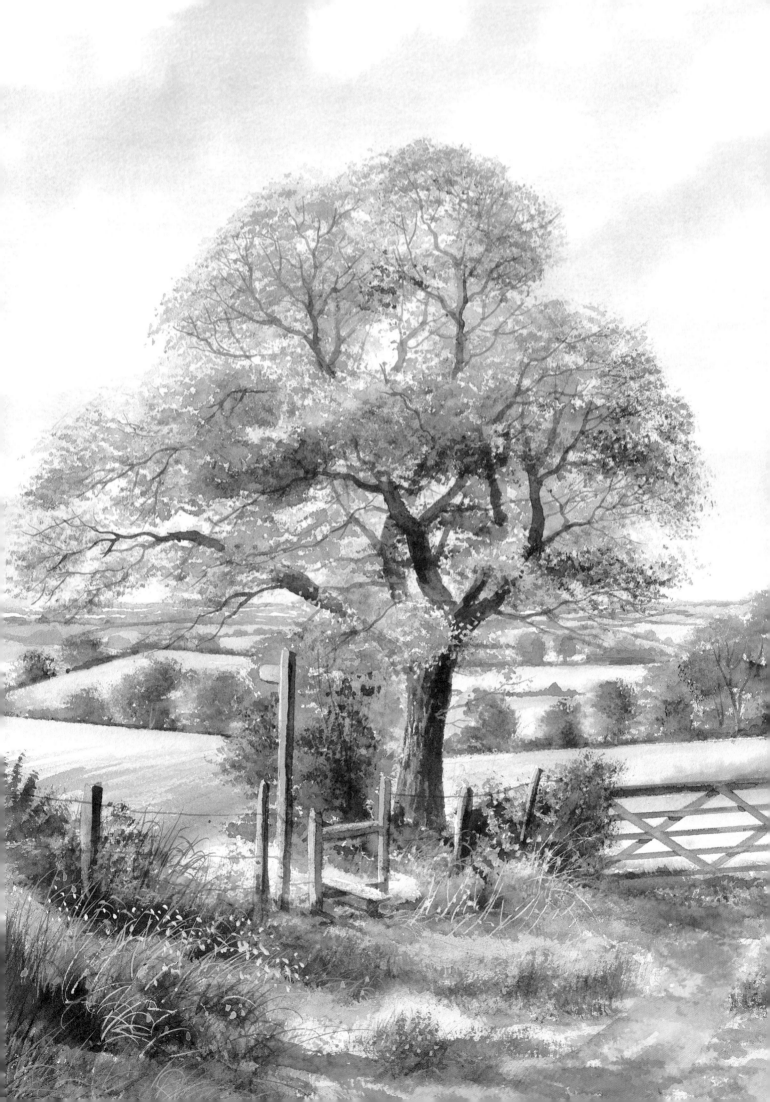

Materials

You will need a range of brushes and a selection of paints. I use only two types of watercolour paper in this book, although you could experiment with different weights and textures.

Brushes

Most artists adapt brushes to suit their needs. I have gone a step further by producing my own range that I have used throughout this book. They are designed to help you achieve the best results easily. Pages 12 and 13 show how the individual brushes can be used to create trunks, branches, foliage and grasses.

Paints

I always use artists' quality colours because the results are so good. It is advisable to buy the best paints you can afford. A lot can be achieved with just the primary colours and a limited palette; however, there are many other colours available if you want to extend your palette.

These brushes are designed to help you achieve good results easily. They are ideal for all kinds of trees, and excellent for a range of effects from creating bark and branch textures to painting foliage and grasses.

Paper

Watercolour paper is available in different weights with three surfaces: rough (called hot-pressed or HP), halfway between rough and smooth (called Not) and smooth. I usually use 140lb (300gsm) rough paper because of its wonderful texture. If I want to include more detail, I use 140lb (300gsm) Not because it is easier to work with a smoother surface.

Stretching paper I never bother to stretch paper before I paint as it takes too long. If a painting cockles when it is dry, just turn it face down on a smooth, clean surface and wipe the back all over with a damp cloth. Place a drawing board over it and weigh it down, then leave it to dry overnight. The cockling disappears as if by magic.

A range of papers with different surfaces are shown here. Rough paper adds extra texture to my paintings; smoother paper is ideal for more detailed pictures.

Other equipment

You do not need lots of equipment. You will have some of the items already and others can be purchased from most art and craft suppliers.

Masking fluid

This can be used to create highlights and for excellent effects that can be painted later. It is an essential part of my equipment and simple to use.

Ruling pen

This can be used with masking fluid to produce fine, sweeping strokes when painting grasses or reeds (see pages 5 and 17).

Soap

To protect your brush, coat it with soap before you dip it into masking fluid. If you do this it will be easier to clean and you can use a good-quality brush without damaging it.

Sponge

A natural or synthetic sponge can be used with masking fluid to create foliage effects.

Pencil and sharpener

I use a 2B pencil for sketching and always keep it sharp.

Eraser

Occasionally, I use a hard eraser to remove masking fluid and to correct mistakes (I find that putty erasers sometimes smudge).

Scalpel

I use a scalpel with a standard blade to trim paper. Be extremely careful when using a scalpel; the blade is very sharp.

Masking tape

I use this to tape the corners of paintings to my drawing board.

Bucket

Brushes need to be properly rinsed if you want them to last, so you need lots of water. In my studio, I use a large bucket with a generous amount of water.

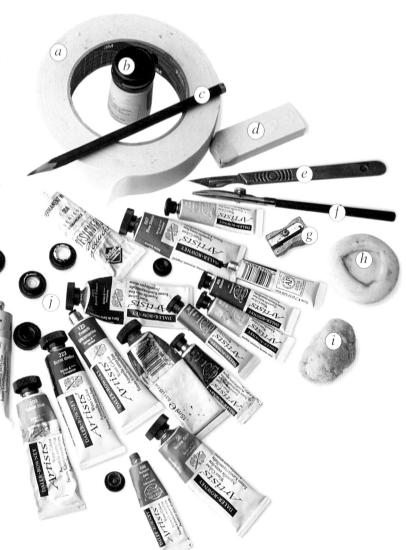

a) Masking tape
b) Masking fluid
c) Pencil
d) Eraser
e) Scalpel

f) Ruling pen
g) Sharpener
h) Soap
i) Sponge
j) Paints

My palette

I use all the colours shown on this page and squeeze them into the pans in my palette. I am then able to mix them in the wells. Also, I am able to use them again because the palette has a lid and the paints do not deteriorate between painting sessions.

Foliage and grasses

Foliage and grasses can be many colours, but they are predominantly green, and greens are used extensively in landscape and tree painting. I have developed my own range of tube colours, including three greens: sunlit green, country olive and midnight green. Below, I show these greens on their own, mixed with cadmium yellow, and mixed with cobalt blue.

Sunlit green

This warm light green can be used straight from the tube or it can be mixed with cadmium yellow to give a richer light green. For a more acid green use lemon yellow. For a cool distant green, mix sunlit green with cobalt blue.

sunlit green

*sunlit green +
cadmium yellow*

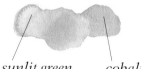
sunlit green *cobalt blue*

Country olive

This is a warm mid-green. Country olive mixed with cadmium yellow will give you a warmer green. For a cooler green, mix it with cobalt blue.

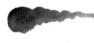
country olive

*country olive +
cadmium yellow*

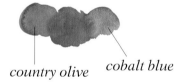
country olive *cobalt blue*

Midnight green

This dark green tends towards blue and is therefore cooler in shade. Mix it with cadmium yellow for a warmer colour, or mix it with cobalt blue for cooler shades.

midnight green

*midnight green +
cadmium yellow*

midnight green
cobalt blue

Alternative mixes for greens

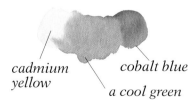

*cadmium
yellow* *ultramarine*
 a warm green

*cadmium
yellow* *cobalt blue*
 a cool green

The colours I use

With this range you can mix most colours.

cadmium red

alizarin crimson

ultramarine

cobalt blue

yellow ochre

raw sienna

burnt sienna

burnt umber

cadmium yellow

Autumn colours

I have developed these colours specifically to capture the tones of autumn. It is difficult to mix them from my basic palette, and much easier to use these tube colours. With their transparent qualities they are ideal for autumn foliage.

Sunlit gold

Autumn gold

Shadow colours

I have developed these unique colours that are ideal for painting shadows!

Shadow

Burnt shadow

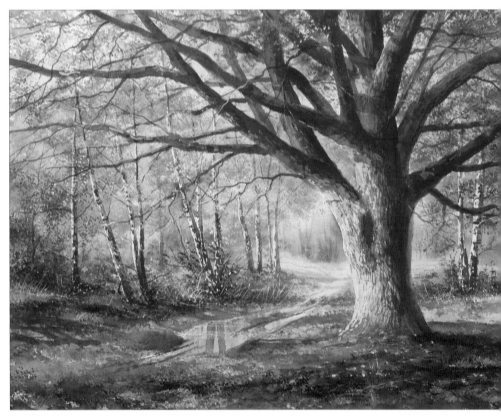

Shades of autumn

The colours sunlit gold and autumn gold capture the beauty of a fresh autumn day in this painting of an oak and a silver birch wood. The shadow colours are worked into the foreground, creating a contrast with the light areas on the tree trunk and in the sunlit glade.

My palette looks a complete mess, but I know where all my colours are, which helps me to find the right one when I need it without interrupting my painting flow. It is a good idea to keep the colours in the same sequence each time you paint. It is so much easier to work in this way.

I group my colours in sections.

Section 1: midnight green, country olive, sunlit green

Section 2: earth colours, which are burnt umber, burnt sienna, raw sienna, yellow ochre

Section 3: reds and yellows

Section 4: blues

Using photographs

In theory, it would be good if we could all set out with our easels and painting kits and spend a lovely day in the open, painting a charming scene. In practice this is rarely possible. I always seem to see something I want to paint when I am on my way somewhere and have no time to paint a picture. This is when I find my camera invaluable.

The camera is an excellent way to capture the silhouettes of trees – as with the photograph of the pine on the right – which really helps to understand their shape. If you are armed with a good set of photographs, it does not matter if the heavens open, or the light changes, or some other crisis occurs – nothing need stop you from finishing your painting. Best of all, your library of photographs will help you to paint any tree at any time of the year.

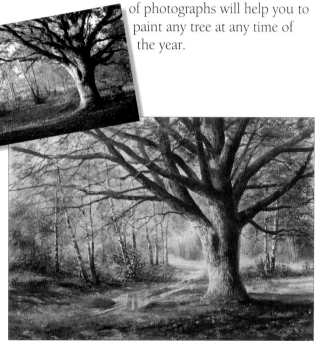

Shades of autumn
This oak tree, with its texture and strong shadows, is a great subject. The photograph gave me all the information I needed, but with a little artistic licence I added the water and the glorious autumn colours.

Scots pine sunset
The silhouetted Scots pine in the photograph is good reference material, with the shape of the tree clearly outlined against a bright sky. I painted it against a soft wet-into-wet background, creating a scene full of misty light and atmosphere.

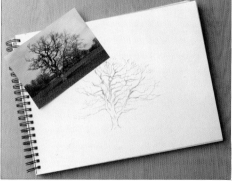

Winter oak
After taking the photograph, I decided to do a sketch of this tree because of its complex structure. This helped me when I started the painting, because I was then able to capture the interesting twists and turns of the branches.

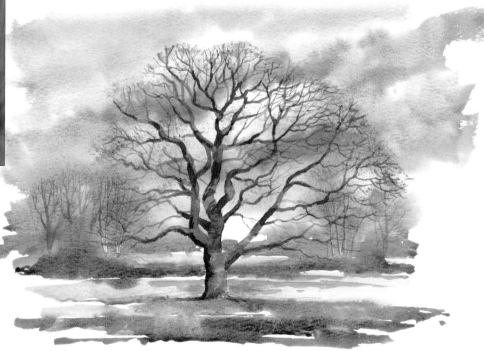

Caught in the afternoon sunlight, this country barn is an excellent subject for a painting. I copied the elements almost exactly, but lightened the foreground in areas and softened the background trees.

Combining photographs

Sometimes, one photograph is not enough, so I combine two or three to produce the effect I want. Elements from the two photographs below have been combined to create this painting: the tree (top), and the signpost, fence and stile (below).

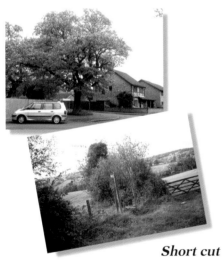

Short cut
Very little has changed in the composition of the elements taken from the stile photograph above, apart from adding the foreground tree and changing the dimensions of the picture. However, the painting is more interesting with the tree as the focal point.

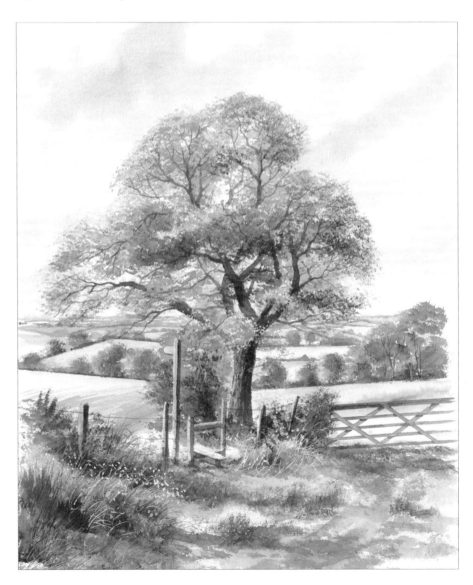

Techniques

Using the brushes

You do not need a huge range of brushes when painting trees. You can create wonderfully realistic effects with the ones shown here.

Large detail

This brush holds a lot of paint, but it still goes to quite a fine point. This is ideal for tree trunks and washes.

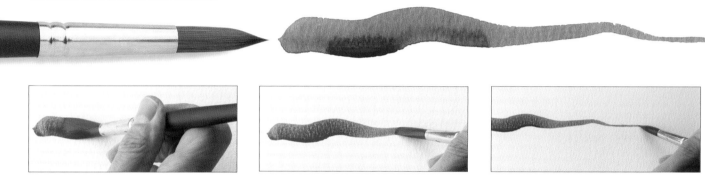

This is an important stroke to master when you are painting tree trunks or branches. Load the brush and press it firmly on the paper, then draw it smoothly along, gradually decreasing the pressure until it tapers to a fine point.

Medium detail

This is ideal for painting more delicate trunks and branches.

Small detail

This is useful for really delicate trees and twigs.

Half-rigger

This goes to a really fine point, so is ideal for very tiny branches. The hair is long, but not as long as a rigger. This brush holds a lot of paint, reducing the need to reload in mid-flow.

Golden leaf

Use this to stipple foliage, and to flick up grasses. This is a stiff bristle brush with a blend of soft hair. When the hair is wet, it curls and separates the bristles, making it an ideal brush for painting texture.

 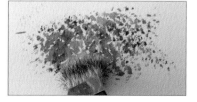

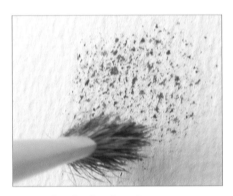

Use a fairly dry brush to create this effect.

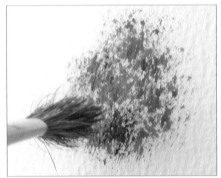

A slightly wetter mix produces a denser result.

Foliage brush

This is a smaller version of the golden leaf brush, and it is good for stippling on foliage and creating texture.

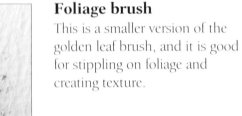

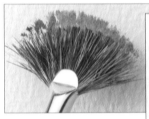

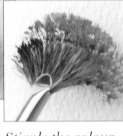

Load one side of the brush with light green and the other with dark green.

Stipple the colour on to create realistic foliage.

Fan stippler

This is a fan version of the foliage brush. Its curved top echoes the shape of trees and it is ideal for all kinds of varieties.

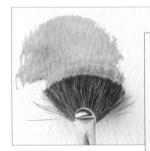

This wet-on-dry effect is ideal for dense foliage.

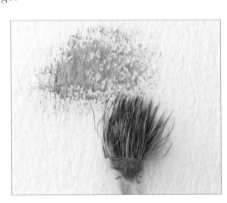

Gently stippling the brush will create a good effect.

Wizard

Twenty per cent of the hair is longer than the rest. Paint is held by the body of the brush and released through the longer hair, which produces some interesting effects.

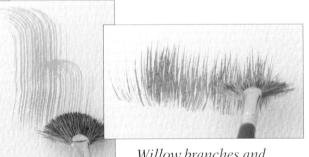

A fairly wet mix of paint is used here for the tree shape.

Willow branches and grasses are easily created with fairly dry brush strokes.

Fan gogh

This is thicker than many other fan brushes. It holds lots of paint and can be used for a wide range of trees, including firs and willows.

Fan gogh px

This slightly larger version of the fan gogh has an angled, clear acrylic resin handle that is great for scraping out trunks.

Different effects

These examples show the results of painting the same tree with the same brush but using different techniques.

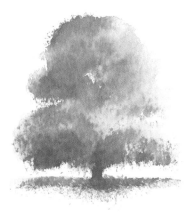

Wet-into-wet: sunlit green, then country olive are applied on to a wet surface with the foliage brush to create subtle blended effects.

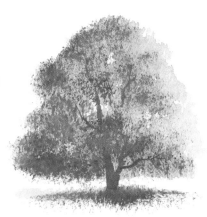

The shape of the foliage is painted first with sunlit green. When dry, country olive is stippled on to define the mass of leaves. The tree trunk and branches are added with a half-rigger.

Using a plastic card

I could not resist including this fun technique for 'painting' the trunks of silver birches. Apply a dark grey paint mix to the edge of an old credit or store card.

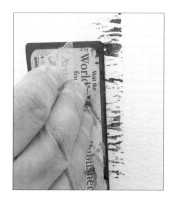

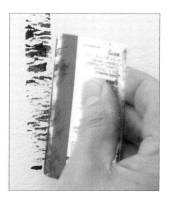

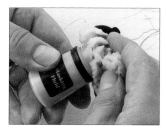

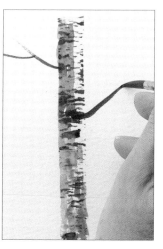

1. Scrape the card across the paper, move it down and repeat to create the trunk.

2. Turn the card over and scrape it the other way to create an uneven texture and bark effect.

3. Use a small detail brush and a mix of cobalt blue and raw sienna, for the shadow.

4. Paint the branches emerging from the knots using a mix of burnt umber and ultramarine.

Using a sponge

Colour can be sponged on to a painting to create an impression of foliage. A sponge can also be used to apply masking fluid when painting trunks, branches and highlights.

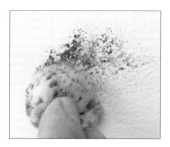

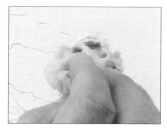

Dip a damp sponge into the paint and stipple it on to the paper to create foliage.

Place a dry sponge on a masking fluid bottle. Tip the bottle gently: the sponge will absorb the liquid.

Apply the masking fluid to the areas where you want to retain the white of the paper.

Tip
Tinted masking fluid is easier to see on white paper. You can add a few drops of paint to the plain variety – the colour will rub off with the dry masking fluid.

Using masking fluid

Masking fluid is ideal for retaining areas of white paper for foliage or lighter effects. Here it is used to create trunks and branches. I have developed a brush specifically for applying masking fluid, or you could use a brush coated with soap (see page 7).

My masking fluid brush

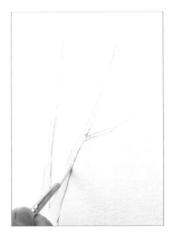

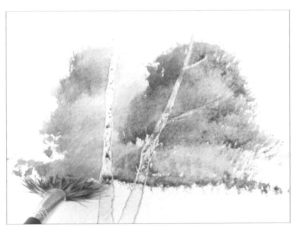

1. Draw outlines of the tree with a 2B pencil. Mask the trunks and branches.

2. With the fan gogh brush and mixes of sunlit green and country olive, paint in the background foliage.

3. Using country olive, dab in the tree foliage.

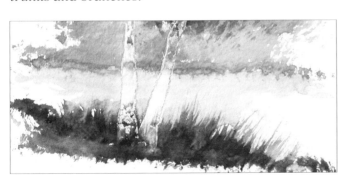

4. Add the grass behind the tree using cadmium yellow and sunlit green, then flick up darker grass under the tree using the fan gogh and midnight green.

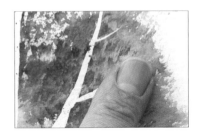

5. Rub away the masking fluid with a fingertip.

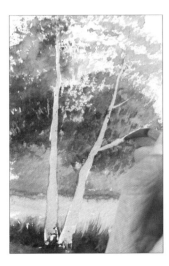

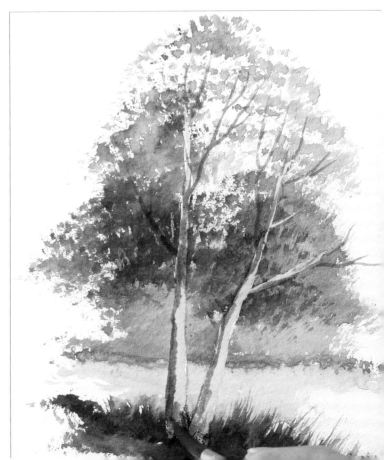

6. Using the medium detail brush and a wash of sunlit green and raw sienna, paint in the trunks and branches.

7. Using a mix of country olive and burnt umber add shadows to the trunks and branches.

Painting snow-covered branches

Masking fluid can be used to produce a convincing snow effect on wintry trees. The dark areas of the trunk are painted in later.

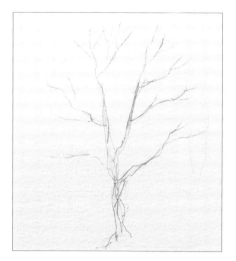

1. Draw an outline using a 2B pencil. Mask snow areas with masking fluid using a brush and sponge.

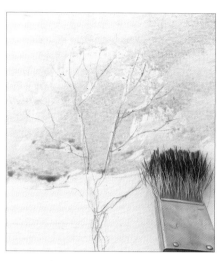

2. Wash in the sky using cobalt blue and the golden leaf brush.

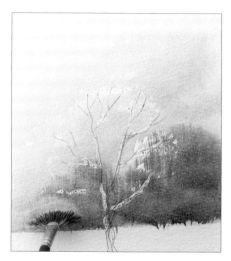

3. With the fan gogh and my shadow colour, paint in the misty background.

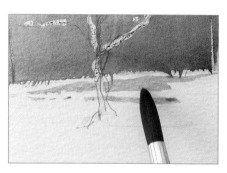

4. Change to the medium detail brush and add cobalt blue highlights to the snowy bank.

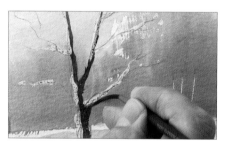

5. Using the half-rigger and a mix of burnt umber and ultramarine, paint in the trunk shadows and undersides of the branches under the masked areas (snow).

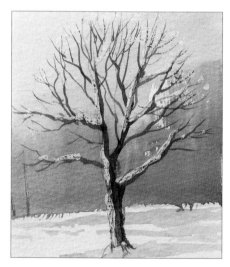

6. Complete all the branches and twigs.

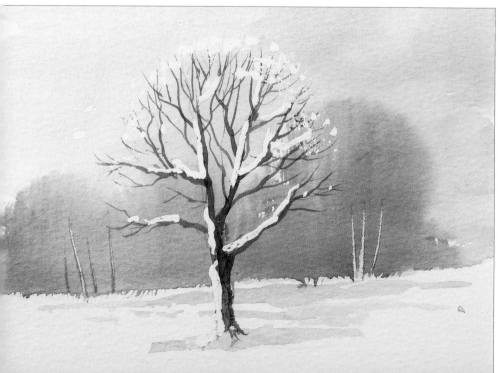

7. Now remove the masking fluid with your fingertip to reveal the snow areas.

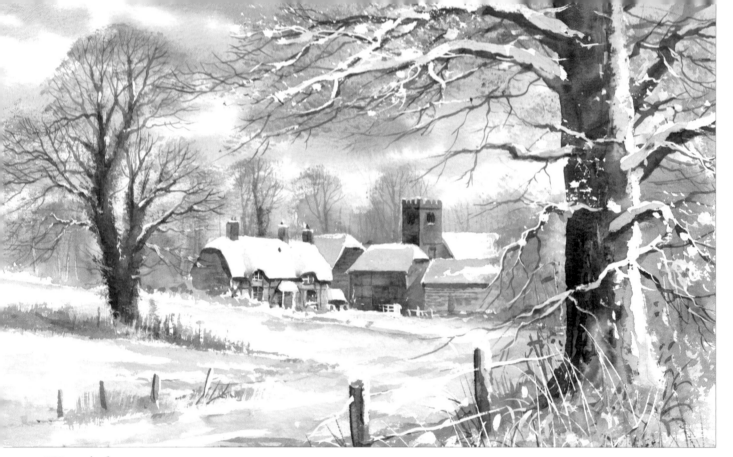

Winter's day
535 x 355mm (21 x 14in)

*Masking fluid is used to great effect to depict the snow laying on the
overhanging branches of the trees and the foreground grasses. Cobalt blue and
shadow colour are added to some of the snow areas after the fluid is removed.*

Using a paper mask

This masking technique produces the effect of a patchwork of fields with
hedgerows. If you use various greens, and make them progressively warmer
as you come forward, you will create a feeling of distance.

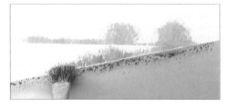

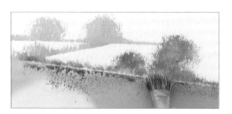

1. Using the foliage brush and a
cool green mix of cobalt blue and
sunlit green, stipple along one
straight edge of the paper.

2. Change the angle of the paper,
resting it against the right hand
side of the first row. Add country
olive to the mix and stipple along
the edge as before.

3. Adjust the paper again. Deepen
and warm the green mix with
more country olive, and stipple in
the foreground hedgerow.

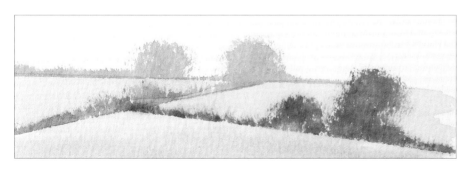

4. Finally, paint in the fields
using diluted washes of sunlit
green, country olive and raw
sienna. With very little effort,
this simple technique gives an
impression of a landscape, and
it is very effective.

17

Painting trunks and branches

Different techniques can be used when painting trunks and branches depending on the type of tree, the season and the effect you want to create. Remember that they are almost never brown. I nearly always use green toned down with shades of brown.

 country olive + burnt umber

country olive + burnt umber + ultramarine

These mixes are ideal for trunks and branches.

If you use the colour mixes shown here, your trees will look more realistic. A flat brown creates a tree that is dull and unnatural. Mix it with green and the tree immediately looks much better.

 burnt umber

 burnt umber and country olive

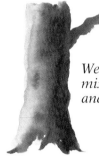 *Wet-into-wet using a mix of country olive and burnt umber.*

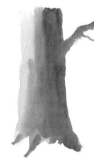 *Wet-into-wet using a mix of country olive and burnt umber, with ultramarine added on the shaded side while still wet.*

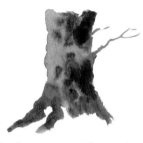 *Wet-into-wet with a mix of country olive and burnt umber. Ultramarine is added for the darker areas.*

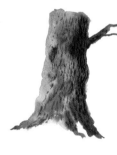 *Wet-into-wet using a mix of country olive and burnt umber. When dry, detail is added with a small detail brush.*

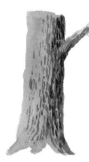 *Wet-on-dry using a mix of country olive and burnt umber. When dry, detail is added using a small detail brush and a stronger mix of country olive and burnt umber.*

 Dry brush on a white background using a mix of country olive and burnt umber.

 Dry brush on a dry country olive background using a mix of country olive and burnt umber.

Painting foliage

Different effects can be used to create an impression of leaves and foliage using a range of brushes or a sponge. Burnt umber and country olive are used to paint the branch, and country olive is used for the foliage, which is painted on a dry background (wet-on-dry).

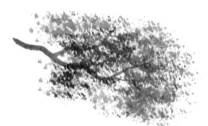

(a) Country olive is stippled on with a fairly dry foliage brush, then midnight green.

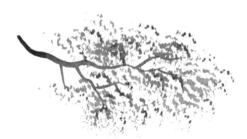

(b) Diluted country olive is stippled on sparingly with a foliage brush. The colour is slightly wetter than (a).

(c) The golden leaf brush is excellent for leaves: a fairly dry brush is used to stipple the foliage over the branch.

(d) This is the same technique as (c) using the golden leaf. Then individual leaves are added with the large detail brush.

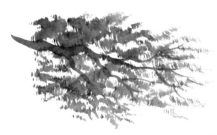

(e) The wizard brush has a ragged edge which is ideal for creating a softer texture. Use a dry brush to create this effect.

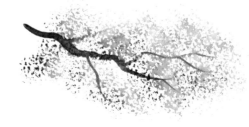

(f) The leaves are dabbed on using a damp natural sponge. You will lose the texture if the sponge is too wet, so keep it fairly dry.

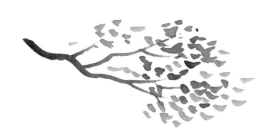

(g) The medium detail brush is used when a tree is close up. Each leaf is dabbed on for a more controlled texture.

(h) The large detail brush is used for a denser effect. The brush strokes are larger and closer together, but gaps are left in the foliage.

Simple trees

It is usually assumed that in order to paint convincing trees you have to know a lot about them. The good news is that you don't! Even after years of painting trees, I am pretty hopeless at identifying anything but the most common types, although I do refer to my sketchbook notes if I need to. On the following pages you will find trees that are remarkably easy to paint, with no name in sight. I am aiming to create impressions of trees, rather than trees with detail.

Painting skies

Learning a few useful techniques will make all the difference to your paintings. As this is primarily a book about trees, I am not attempting to tackle skies (it would be impossible in such a short book to cover all the tricks I have picked up over the years); however, it is useful to understand how to paint a simple sky like the one below.

Laying a wash

A basic blue wash is a useful background if you plan to cover a painting with trees. If you want to create a feeling of distance in the sky, use a graded wash so that the colour fades away towards the horizon.

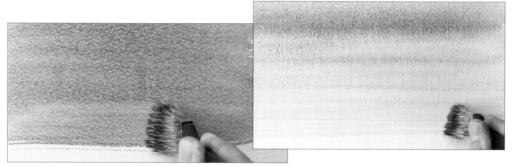

A graded wash can be applied to create a feeling of distance. Wet the paper first, then load the brush with ultramarine. Start at the top and move down the paper with horizontal brush strokes. The water on the paper dilutes the colour in the brush and it becomes lighter towards the horizon.

A simple sky can be created with a flat wash on dry watercolour paper using the golden leaf brush.

Wet-into-wet trees

Painting colours wet-into-wet creates interesting effects and it is wonderful for trees. Start by putting on a basic graded ultramarine wash on wet paper using the golden leaf brush. While the wash is still wet, paint in the trees using the fan gogh brush.

1. Double load the fan gogh brush with sunlit green on one side and midnight green on the other. Start to paint in the first tree...

2. ...angling the brush from side to side as you work downwards to create the feeling of sunlight and shadow.

3. Using the same technique, add the second tree. The paint will spread and blur before it dries to produce a soft, misty effect.

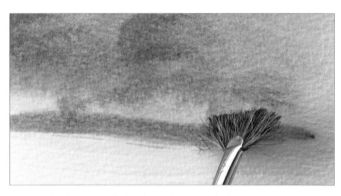

4. Load the brush with country olive, hold it horizontally, and paint in a line beneath the trees.

5. With the tip of the bristles, add the suggestion of the trunks.

Scraping out

The trunks of simple wet-into-wet trees can be 'scraped out' using the handle of a brush or a fingertip. This is a surprisingly effective technique. The outlines will blur as the paint dries, so you should not need to do any more work on the trunks. The handle I use belongs to the fan gogh brush. It has a clear acrylic resin handle which is ideal for scraping out trunks.

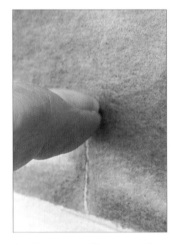

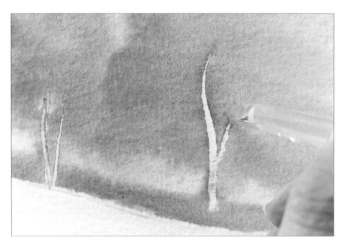

6. Use your fingernail or the corner of a credit card to scrape out the shape of the smaller trunk.

7. Use the handle of a brush, preferably made from clear acrylic resin, to scrape out the shape of the trunk on the larger tree.

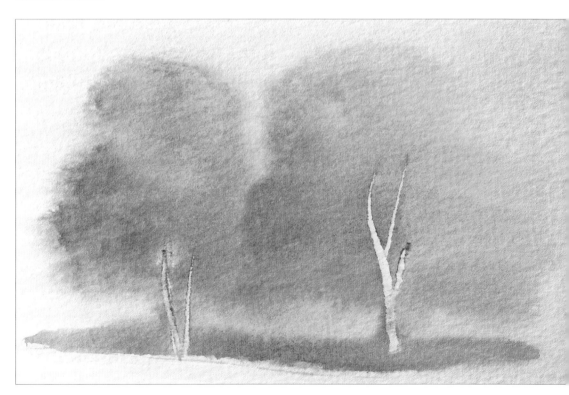

The finished trees.

Look no trunk!

This must be the easiest possible tree to paint. No trunk, no hassle – just a fan stippler brush, double loaded and used to dab on foliage. The effect is finished off with an impression of grass beneath the trees.

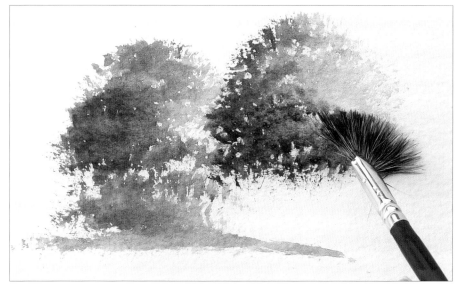

1. Lay the right hand side of the fan stippler in sunlit green, then angle the brush and lay the left hand side in country olive. This is called 'double-loading' and it creates sunlight and shade in foliage. Dab the paint on to the paper, angling the brush from side to side as you do so.

2. Lay the right hand side of the brush in sunlit green and the left hand side in midnight green and paint the second tree as before, with its darker edge overlapping the sunlit side of the first tree.

The finished trees: the same brush is used to dab in the foreground grass.

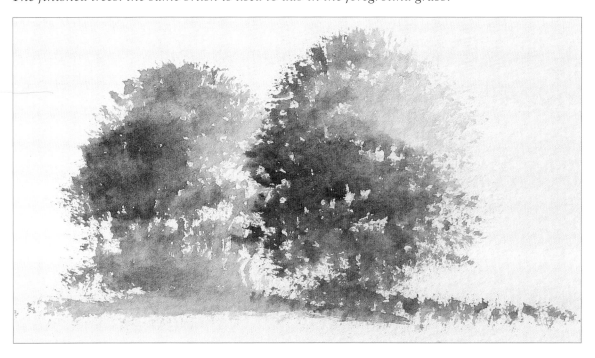

Keep it simple

For this basic tree, the trunk and branches are painted first with a half-rigger and the foliage is dabbed in afterwards. One of the most important things to remember is that most trunks are not brown. Use a mix of green toned down with a little burnt umber.

 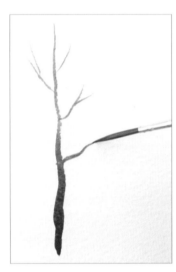 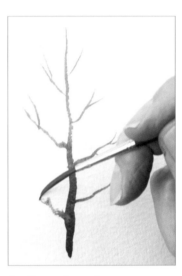 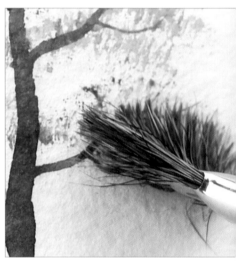

1. Paint in the trunk with one upward stroke.

2. Add the branches using the same brush.

3. Complete the framework of the tree.

4. Change to the fan stippler and sunlit green, and begin to add the foliage, keeping the effect light.

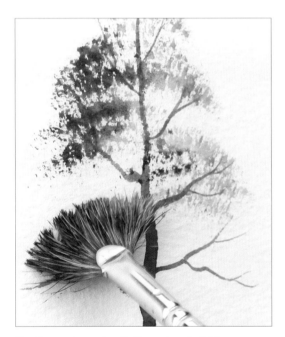

5. Complete the foliage by dabbing on darker tones of country olive.

The finished tree: the grass beneath the trunk is created by flicking the same greens upwards with the fan gogh brush.

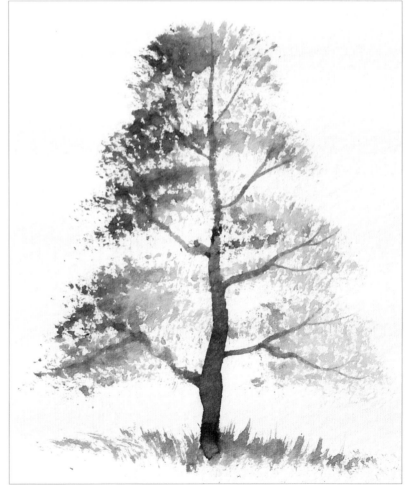

Thicker foliage

This tree is painted in a similar way to the previous tree, with the trunk and branches painted in before the foliage. This time, the foliage is thicker – use the fan stippler brush as before but load it with more paint so that the colour runs into the textured paper.

1. Mix green and burnt umber and start painting in the trunk using the half-rigger.

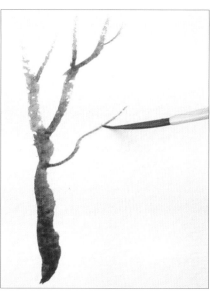

2. Add finer branches, tapering them off towards their ends.

3. While the trunk and branches are still wet, stipple on sunlit green double loaded with a little country olive using the fan stippler. The colours will blend together and the branches will disappear into the foliage.

4. Use midnight green under the foliage and for the shadowed side of the tree.

The finished tree: the grass beneath the trunk is created with the fan gogh brush and the same greens.

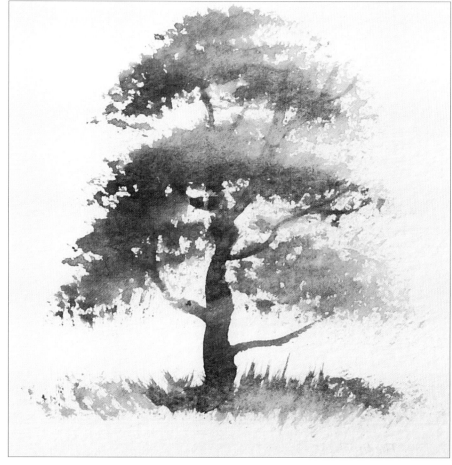

Foliage first

The foliage on this tree is fairly thick, so it is painted first using the fan stippler brush and a double loading technique. When you are happy with the effect, add the trunk and branches between the clusters of foliage. Do not try to be too precise: remember that you are aiming for an *impression* of a tree.

1. Double load the brush with sunlit green and country olive. Begin to dab in areas of foliage leaving gaps.

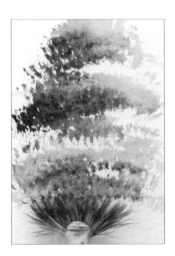

2. Work downwards, varying the angle of the brush to complete the light and dark areas.

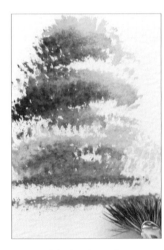

3. Hold the brush horizontally and lay in a line beneath the tree.

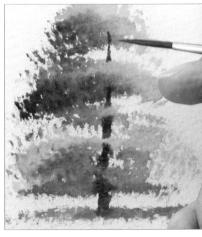

4. With the half-rigger, paint in the trunk where it shows through the foliage, using burnt umber and country olive.

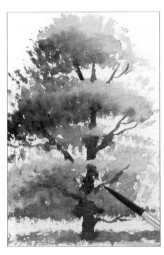

5. Still using the half-rigger, paint in some finer branches.

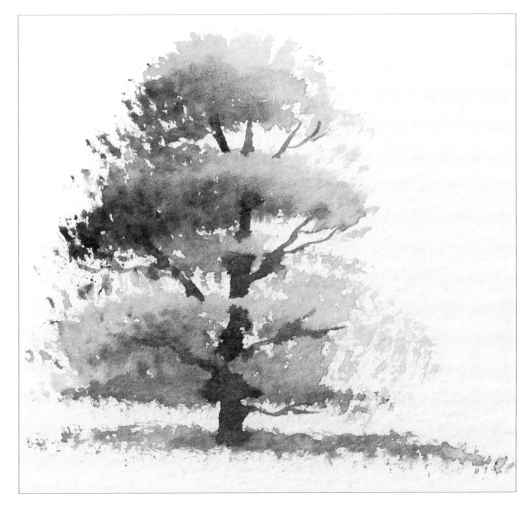

The finished tree.

Spring tree

Spring foliage is easy to paint, with its light, new leaves. This simple tree reflects the freshness of the season.

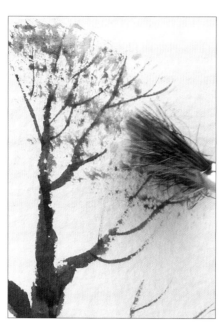

1. Using burnt umber and country olive, sketch in the tree with the medium detail brush, then add finer branches using the half-rigger.

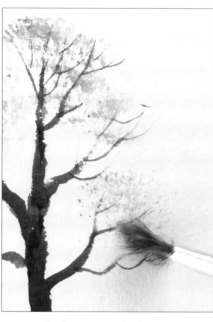

2. Using the fan stippler and sunlit green, start to lightly stipple on the foliage. The brush should not be too wet.

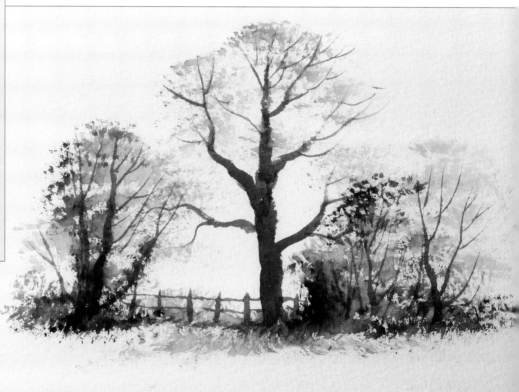

3. Work downwards, keeping the effect light and airy.

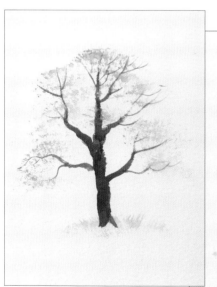

This painting captures the mood and atmosphere of the season. The range of green tones blend together in a harmonious composition that portrays spring.

Summer tree

In the height of summer, when a tree is in full leaf, it is not always easy to tell what type it is. This impression of a tree is very easy to create and can it be used to represent lots of different types of tree, especially when they are massed together.

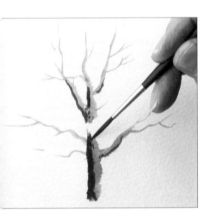

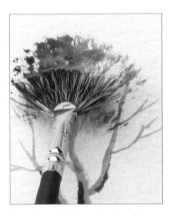

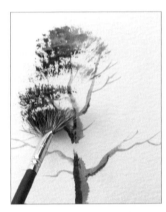

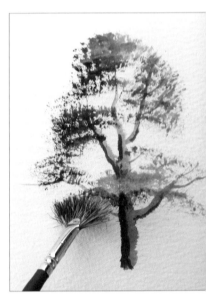

1. Sketch in the tree using a half-rigger and country olive. Add the shadows using country olive and burnt umber. Leave a gap at the front for an area of foliage.

2. Double load the fan gogh brush with sunlit green and country olive and start dabbing on the foliage.

3. Move downwards, angling the brush and stippling on areas of light and dark foliage to create an impression of sunlight and shadows.

4. Fill in the 'hole' at the front of the tree with an area of light green. Stipple the foliage across the trunk.

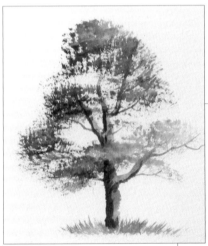

This is the same scene as the painting opposite. The denser summer foliage is darker and richer, and the feeling is warmer. The fence is now covered with thick grasses and bracken and the background is overgrown.

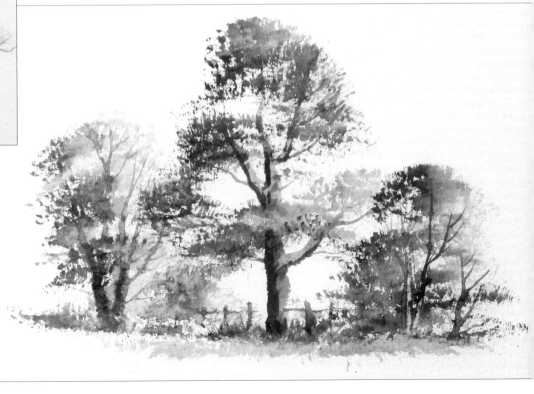

Autumn tree

The rich, vibrant reds and yellows of autumn are wonderful in any wooded landscape. I love painting this time of year. Here, the foliage is stippled in over the tree framework, which is a mix of country olive and burnt umber.

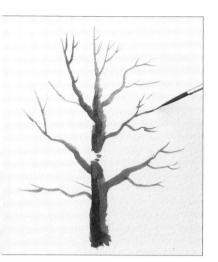

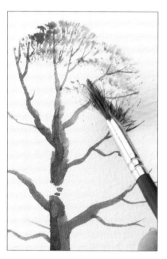

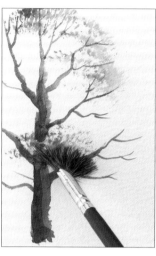

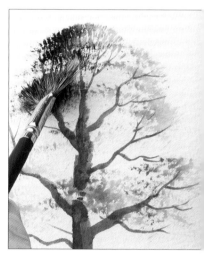

1. Paint the trunk using the medium detail brush, leaving a gap at the front. Add the larger branches, then change to the half-rigger and paint the finer branches.

2. Double load the fan stippler with autumn gold on the left hand side and sunlit gold on the right hand side. Start to stipple in the foliage.

3. Move down the tree to the gap in the trunk. Stipple in an area of foliage, angling the brush from side to side to create the golden autumn shades.

4. Add some burnt shadow to the brush and start building up the darker tones down the left hand side of the tree.

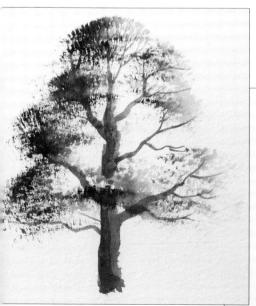

The tree is transformed with its autumn colours. The golden and russet hues create a glorious seasonal painting.

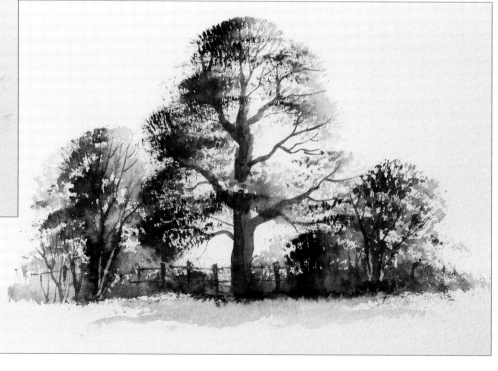

Winter tree

The stark framework of a deciduous tree can make a compelling painting and immediately evoke a feeling of winter. Here, I have painted in the trunk and branches with a mix of country olive and burnt umber and added a canopy of twigs.

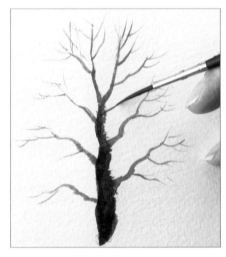 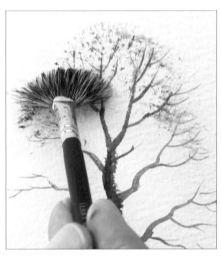

1. Paint in the trunk and larger branches with the medium detail brush, then add the finer branches with the half-rigger.

2. Using the fan stippler and a fairly dry mix of shadow colour, start at the top of the tree and lightly stipple over the branches.

3. Working downwards and still stippling lightly, complete the canopy of twigs.

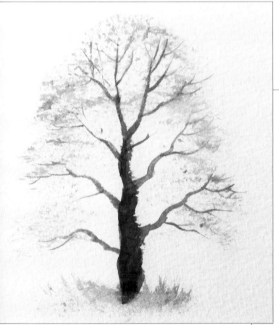

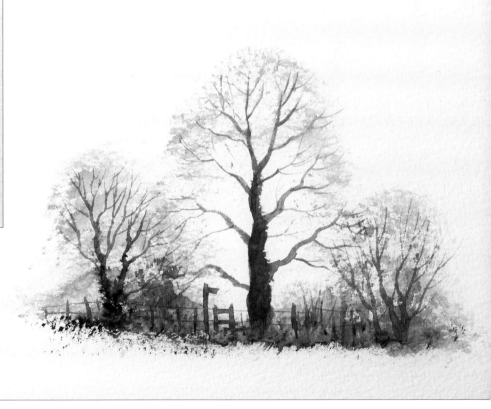

The trunks and branches are prominent in this winter scene. They are softened with stippled impressions of twigs in shadow tones which help to create the wintry atmosphere.

Winter tree with ivy

Occasionally you will see winter trees with their trunks densely covered in ivy. I love painting this subject because it adds character to a tree. The important thing is not to get involved with detail. It is easy to create an impression of ivy with this simple technique. Use the fan stippler brush and midnight green.

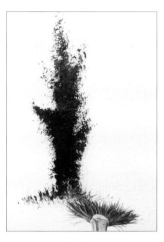

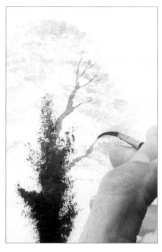

4. Using the half-rigger and a light mix of cobalt blue and shadow colour, paint in the background branches.

1. Hold the brush at right angles to the paper and dab in the shape of the trunk.

2. Turn the brush and flick up some grasses beneath the trunk.

3. Load the brush with shadow colour and dab in the canopy of twigs.

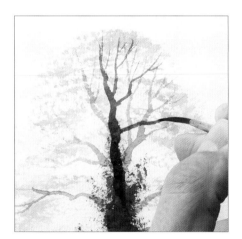

5. Using a darker mix of shadow colour and burnt umber, paint in the trunk and the branches at the front of the tree. Remember that the tree is three dimensional. To create a feeling of depth, the lighter branches are in the background and the darker ones are at the front of the tree.

The finished tree.

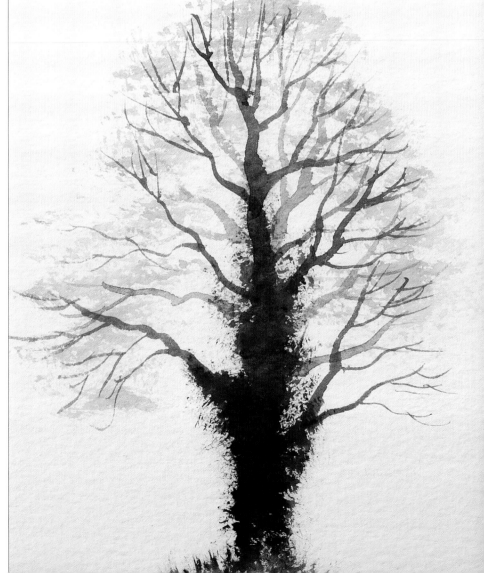

Winter copse

This scene is initially worked wet-into-wet so that shapes soften and blur. Then the network of trunks and branches are painted when this background is dry. The combination of techniques captures the atmosphere of a cold winter's day. The same techniques can be used to create misty landscapes.

1. Wash in a cobalt blue sky with the golden leaf brush.

2. While the paper is still wet, add the shapes of trees with the fan stippler and shadow colour.

3. Using raw sienna, keep adding the tree shapes while the paper is still wet.

4. Before the paper dries, stipple midnight green ivy on to the central tree.

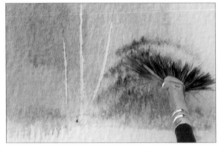

5. Scrape out the trunks of the smaller trees with a fingernail or the corner of a credit card. Add the foliage on the right using burnt sienna. Leave to dry.

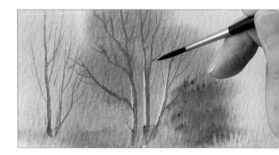

6. Using the half-rigger and shadow colour, paint down one side of the scraped-out areas. This will create an impression of sunlight and shade. Paint all the trunks and branches using the same colour.

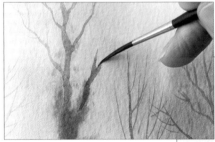

7. Add the fine branches with the half-rigger.

The finished painting: is small copse is made more atmospheric with the use of wet-into-wet washes and subdued colours.

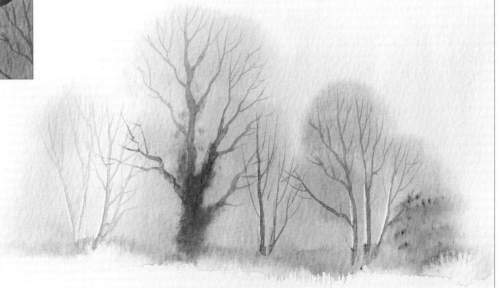

Moving on

The following pages contain simple techniques that can be used to paint a variety of known trees. I begin with the very simple cypress below, and include demonstrations later on for more challenging trees.

Speedy cypress

One of the easiest trees to paint is a cypress. No trunk, no branches – just a sunlit side and a shaded side.

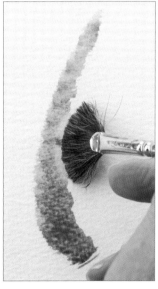

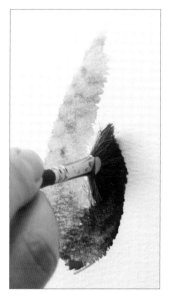

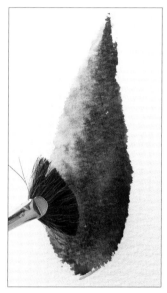

3. Hold the brush at an angle and blend the greens.

1. Load the fan gogh with sunlit green. Paint from the outside edge towards the centre of the tree, following the cypress shape.

2. Using country olive, paint the other side of the tree in the same way while the lighter green is wet. Allow the two colours to merge.

Tip
If you find some painting angles difficult, simply turn the paper around.

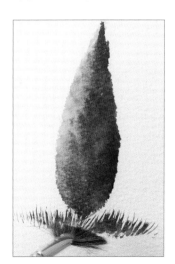

4. Using the same greens, flick grasses up at the base of the tree.

The finished tree: the cypress looks three dimensional with its sunlit foliage contrasting strongly with the darker shadows.

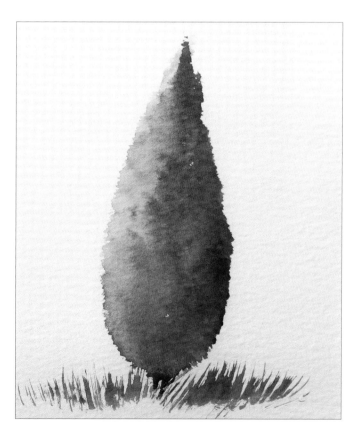

Loose spruce

The fan gogh is ideal for creating fir trees. The shape of the brush is the same as the shape of the branches. Load the brush quite fully as the foliage is thick and you need to achieve a fairly solid effect.

 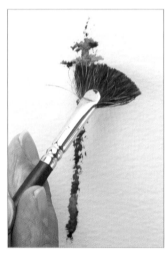 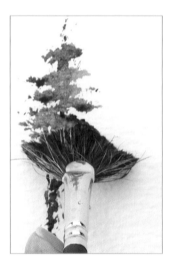 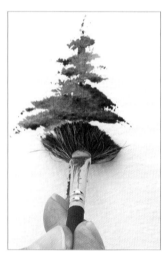

1. Hold the brush at right angles to the paper and dab a vertical line on to the surface using midnight green.

2. Turn the brush and use the corner to paint in the small branches at the top of the tree.

3. Paint in more branches, keeping the effect loose and free.

4. Use progressively more of the brush as you work downwards, pushing it firmly into the paper. Zig-zag down the trunk...

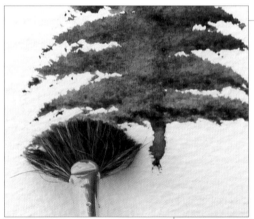

5. ...until you reach the bottom of the tree.

6. Using the same green, add a suggestion of grass beneath the tree with broad sweeps of the brush.

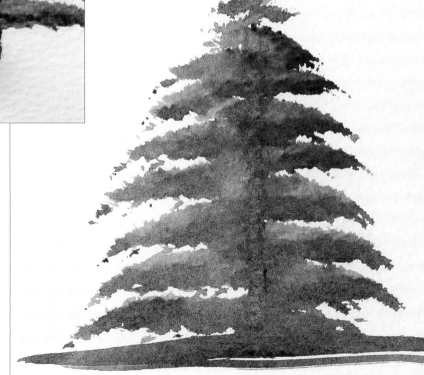

Lonesome pine

This Scots pine is simple to paint and is one of the few trees to have a brown trunk. Start with the framework and then add the foliage. If you have photographs of these trees, refer to them when following this demonstration (see page 10). This will help you to become familiar with the shape which will be useful for future paintings.

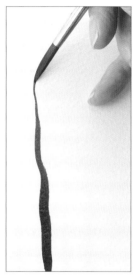

1. Paint the trunk using the medium detail brush and burnt umber.

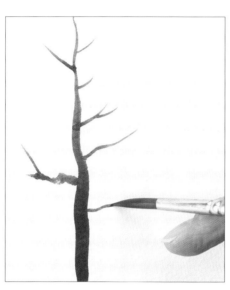

2. Add the branches, pulling the brush away from the trunk, tapering the strokes lightly.

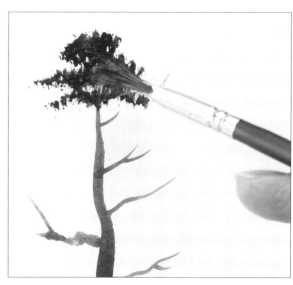

3. Change to the fan stippler brush and midnight green, and dab in the foliage.

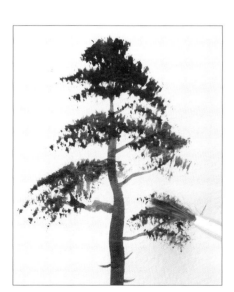

4. Work down the tree, dabbing more foliage on to the branches to create the pine shape.

5. Finally, flick up some grasses beneath the tree using the same green.

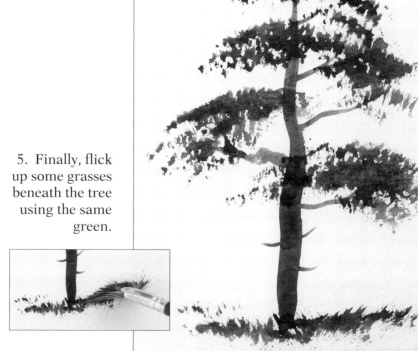

Weeping willow

Once you have mastered the technique for dragging down the foliage, the willow is simple to paint. Use a fairly dry fan gogh brush and not too much sunlit green.

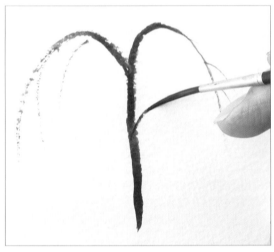

1. Using the half-rigger and a mix of country olive and burnt umber, paint in a simple framework.

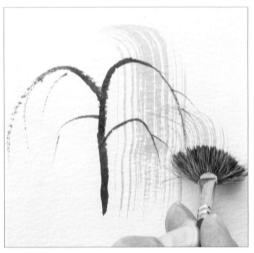

2. With the fan gogh brush and sunlit green, use the tip of the brush and 'drag' foliage over the branches, curving the top of each stroke and pulling the brush downwards.

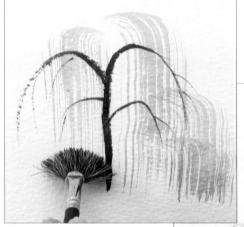

3. Complete the other side of the willow in the same way.

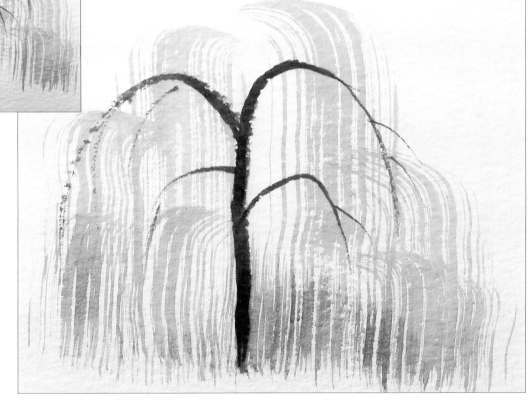

This impression of a willow is very effective when used in a landscape, yet the techniques are simple.

Popular poplar

I think the reason why I am often asked to paint these trees is that people like them! Joking apart, they are much easier than they look.

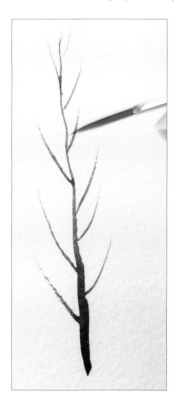

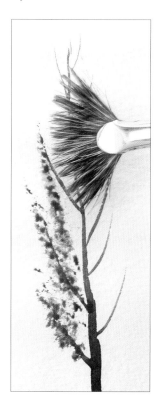

1. Using the half-rigger with a mix of country olive and burnt umber, paint in the delicate framework of the tree. The branches are painted upwards at a steep angle.

2. Change to the fan stippler and sunlit green with a little country olive. Stipple the foliage in at an angle, following the curve of the branches.

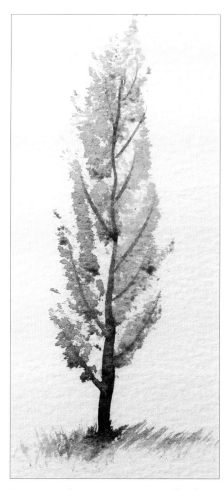

3. Using the same greens, flick the grasses up beneath the tree.

Simple palm

This must be one of the easiest trees to paint. There are two ways to paint the leaves. For the first method, simply paint them straight on to the paper as shown below.

1. Using burnt umber, sweep a double trunk upwards with a fairly dry medium detail brush. The rough surface of the paper gives a textured effect.

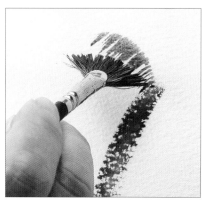

2. Using midnight green and the fan gogh, paint in the first leaf with a downward stroke of the brush. All the leaves start at the same point on the trunk.

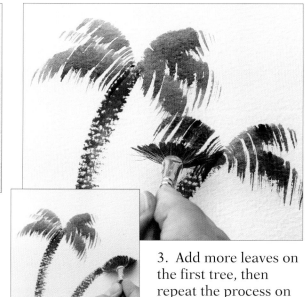

3. Add more leaves on the first tree, then repeat the process on the second tree.

Perfect palm

This is a very simple method and just as effective. Paint in the central ribs first, then add the sweeping fronds.

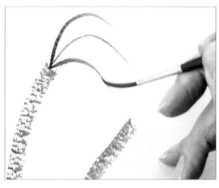

1. Paint the trunks as before. Then, using the half-rigger and midnight green, start to paint in the ribs of the leaves.

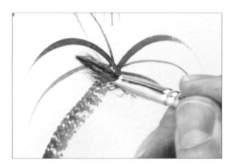

2. Finish painting the ribs. Then load the fan gogh brush with midnight green. Line up the brush on the first rib.

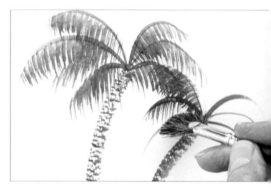

3. Drag the brush downwards to create the fronds. Repeat on the other ribs.

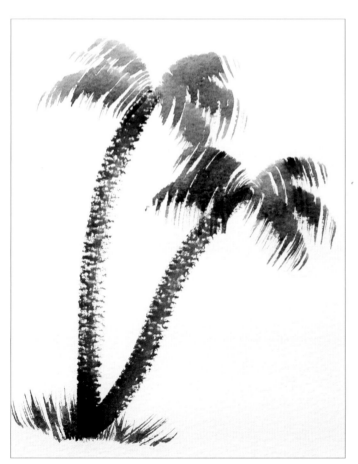

The finished paintings: either of these methods can be used to create convincing palm trees. The dry-brush trunks give an impression of texture and the fan gogh brush is ideal for creating the sweeping palm leaves.

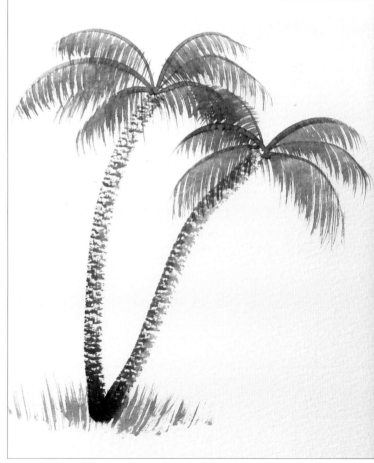

Apple tree in blossom

It can be difficult to reproduce blossom convincingly. Here, I use masking fluid to suggest drifts of blossom, which is often better than trying to paint every flower. This technique is extremely effective and it can be used on all types of blossom-bearing trees.

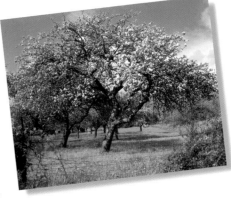

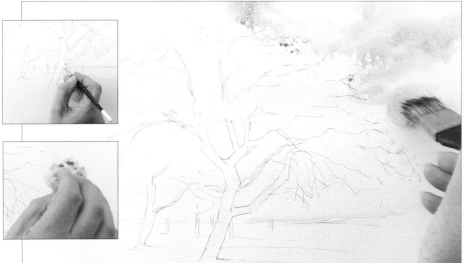

1.Using a 2B pencil, sketch in the main outlines. Referring to the photograph above and using masking fluid, first 'paint' over the sunlit areas of the trunk and branches' then sponge it in drifts across the branches to be covered by foliage. Each little 'dab' of masking fluid will represent blossom. Allow the fluid to dry. With the golden leaf brush and cobalt blue, paint in the sky.

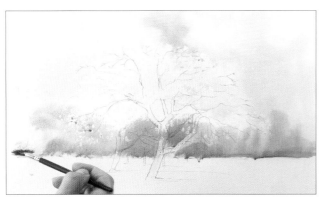

2. Working wet-into-wet and using the fan gogh brush and cobalt blue with sunlit green, paint in the background behind the tree, allowing the colours to merge. Do not make this area too dark. Leave to dry.

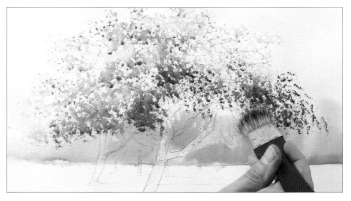

3. With the golden leaf brush and mixes of sunlit green and country olive, stipple in the foliage. Use more of the darker green as you work down the tree.

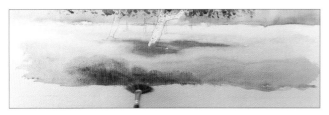

4. Using the fan gogh brush and sunlit green, country olive and raw sienna, paint in the grass and shadows beneath the tree.

5. With the medium detail brush and a dark green mix of midnight green and burnt umber, paint in the unmasked areas of the trunk and branches.

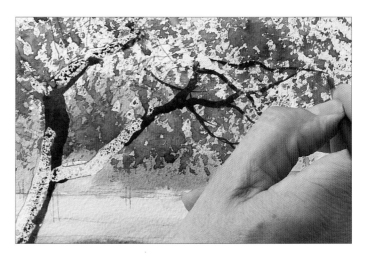

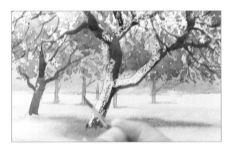

6. Using the small detail brush and a mix of country olive and cobalt blue, paint in the tree trunks and their shadows in the middle distance.

7. Rub away the masking fluid to reveal the white areas.

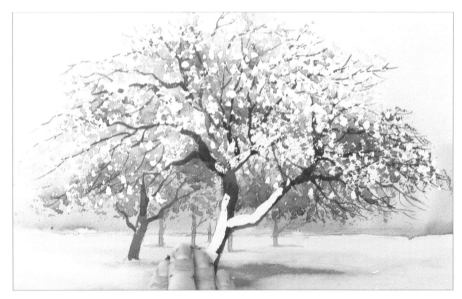

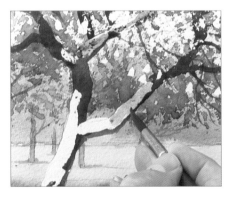

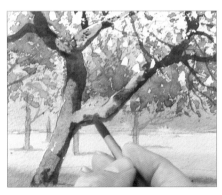

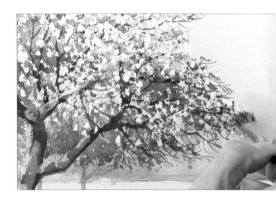

8. With the medium detail brush and a light mix of sunlit green and burnt umber, paint in the sunlit areas on the trunk and branches.

9. Add shadows using a mix of burnt umber and country olive.

10. Using the foliage brush and a touch of alizarin crimson, stipple colour over the blossom.

The finished painting
510 x 330mm (20 x 13in)

Longer grass is added beneath the two main trees and in the foreground by flicking up midnight green with the fan gogh brush.

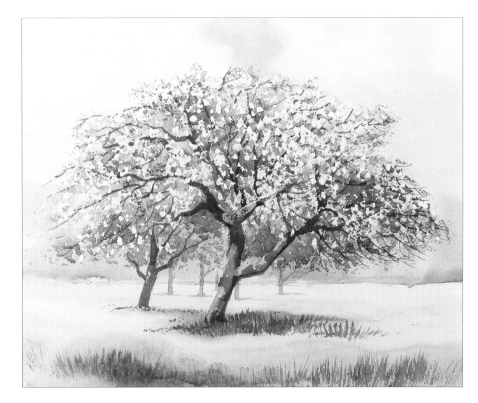

Oak tree

I drove past this scene many times thinking 'nice tree, but shame about the surroundings', then finally decided to park and take a photograph. A bit of tinkering – otherwise known as artistic licence – was needed to remove the road signs and tarmac. I also decided to paint the oak tree standing alone and this is the result.

1. Using a 2B pencil, lightly draw the main outlines of the picture. I have retained the fence, and will replace the tarmac foreground with grass.

2. Wash in a simple sky using the golden leaf brush and cobalt blue. Then, working wet-into-wet, paint in the background foliage with the fan gogh brush and using shadow tones...

3. ...and country olive. While the foliage is still wet, drop in burnt umber behind the tree on both sides.

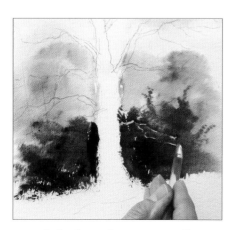

4. While the colours are still wet, use a brush handle to scrape away branches on the right hand side of the trunk.

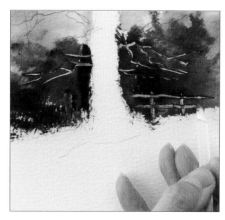

5. Repeat this on the left hand side, then scrape away the shape of a fence.

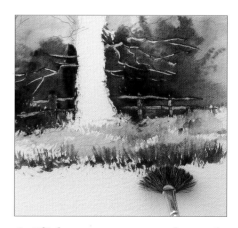

6. Flick up some grasses beneath the tree using the fan gogh brush and sunlit green, burnt sienna and country olive.

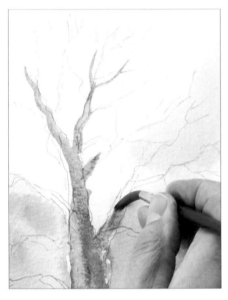

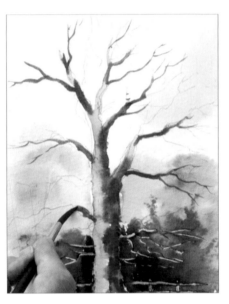

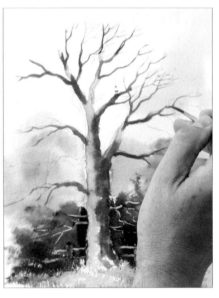

7. Using the medium detail brush and a mix of country olive and burnt umber, paint in the tree trunk and upper branches.

8. Paint in the darker shadow areas with a mix of country olive and burnt umber, starting at the top and working downwards.

9. Change to the half-rigger and add the tiny branches.

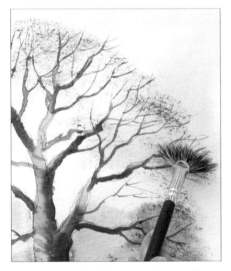

10. Using the fan stippler and shadow colour, dab in the canopy of twigs.

The finished painting
280 x 310mm (11 x 12¼in)
I use photographs for reference only and often use artistic licence to create more pleasing compositions. The solitary oak tree is sunlit against dark winter foliage in a peaceful setting, instead of being portrayed on a busy junction.

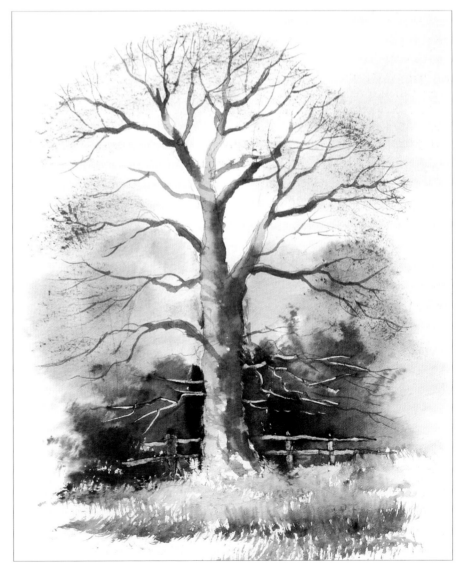

Silver birch

The delicate trunk and texture at the base of the tree make the silver birch a favourite with artists, and I am no exception. When I am working in watercolour I often use masking fluid to reproduce the characteristic trunk. I have also devised a technique that uses an old plastic credit or store card to produce an amazingly fast and convincing effect (see page 14). When you paint the trunks, remember to make them darker towards the ground.

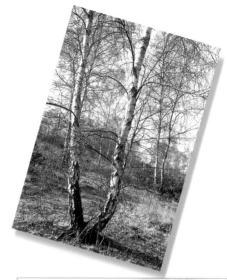

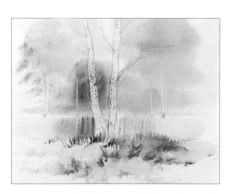

1. Using a 2B pencil, draw in the trees and paint masking fluid on to the trunks. Remember to coat your brush with soap before using the fluid.

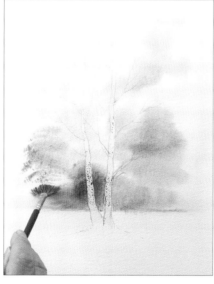

2. Wash in a cobalt blue sky, then, using the fan gogh brush and cobalt blue with sunlit green, paint in the soft background tones wet-into-wet.

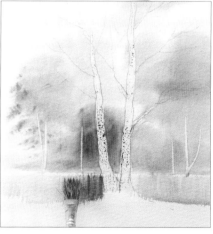

3. While the background is still wet, scrape away the distant tree trunks with a brush handle. Using the wizard and sunlit green with cobalt blue, wash in the water. Add the reflections with downward strokes of the brush, working wet-into-wet.

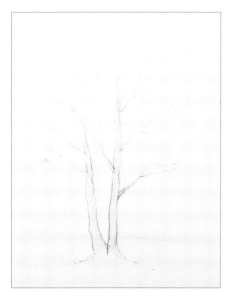

4. Using the fan gogh brush and sunlit green, country olive and raw sienna, flick up an area of grass beneath the trees.

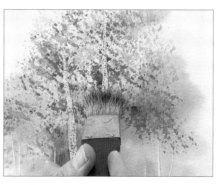

5. Change to the golden leaf brush and dab in foliage over the tops of the trunks using sunlit green and country olive.

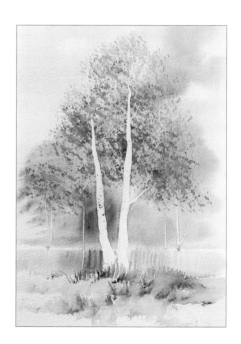

6. Using a fingertip, gently rub off the masking fluid.

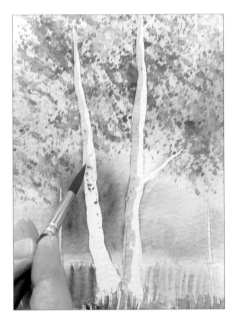

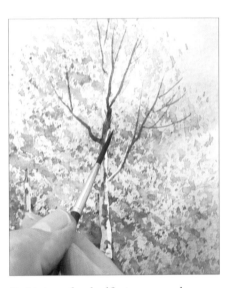

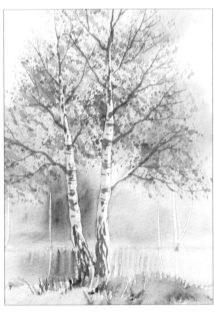

7. Using the small detail brush and diluted cobalt blue with a touch of raw sienna, paint in the shadows on the trunks.

8. Using the half-rigger and a mix of ultramarine and burnt umber, paint in the bark texture and add the darker branches.

9. Paint the bark at the base of the trees, where the bark splits, leaving little islands of white.

10. Finally, using the golden leaf brush and country olive, dab in areas of foliage over the top of the trunks for a natural effect.

The finished painting
280 x 310mm (11 x 12¼in)
I used a photograph on the top of the opposite page for reference but made the composition more pleasing by painting the silver birches in full foliage on a quiet riverbank.

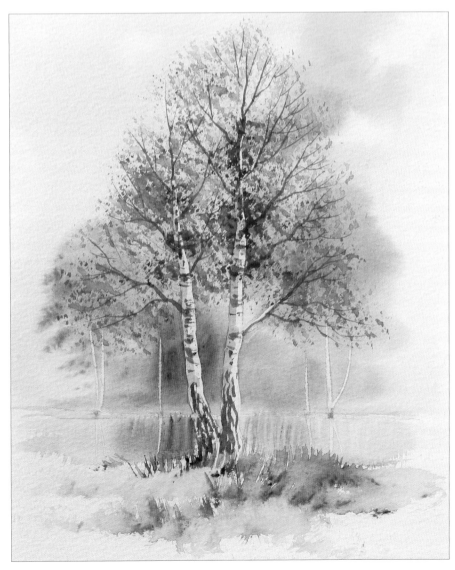

Horse chestnut

Most trees, unless they are specimen trees in arboretums, are not seen standing alone. The horse chestnut is an exception in that you will often see just one, perhaps in the middle of a park or playing field. I have used masking fluid to give an impression of the characteristic 'candles' but you can omit this element if you prefer just to paint the shape of the tree.

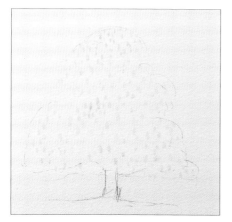

1. Sketch the outline of the tree using a 2B pencil, then use masking fluid to paint in the 'candles'. (Remember to coat the masking fluid brush with soap.)

2. Dampen the paper and, working wet-into-wet with the golden leaf brush, paint in the cobalt blue sky. Add the soft background using cobalt blue and sunlit green. Allow to dry. Using the fan stippler and sunlit green, start to stipple in the lighter shades of the tree.

3. Using country olive, add the medium shades to selected areas of the tree.

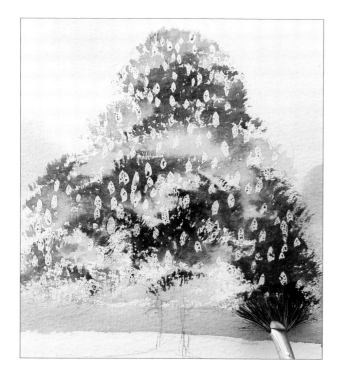

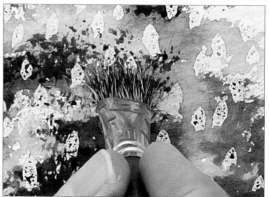

4. Using the foliage brush and midnight green, add darker shades and more texture on a dry background.

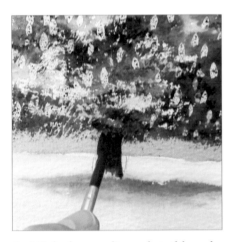

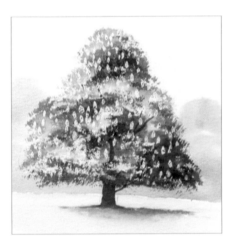

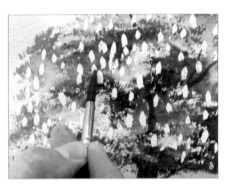

5. With the medium detail brush and sunlit green, paint the grass, adding the shadow with country olive. Using a midnight green and burnt umber mix, paint in the trunk.

6. With the same brush and paint mix, add a few branches within the foliage, tapering the ends to give a realistic effect.

7. Remove the masking fluid with a fingertip. Using a mix of sunlit green and raw sienna, take the starkness off a few of the 'candles'.

The finished painting
310 x 280mm (12¼ x 11in)
Simple techniques can be combined effectively to create this horse chestnut with its distinctive 'candles'.

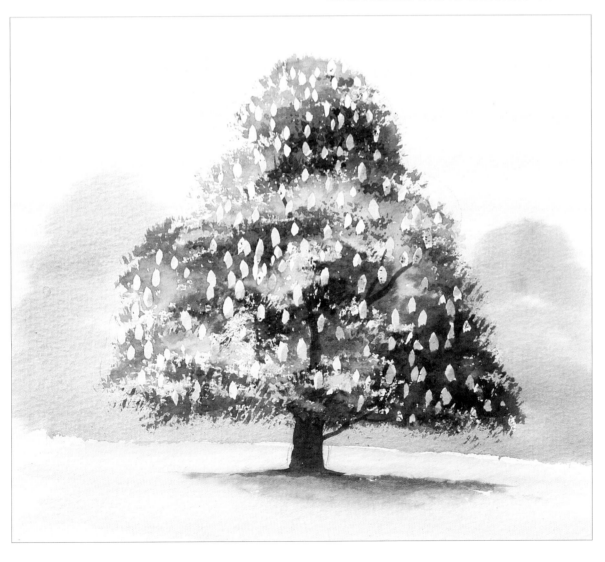

Olive tree

These splendidly gnarled trees are a feature of the Mediterranean landscape. Here the strong foreground tones of the textured bark, branches and dark foliage contrast beautifully with the paler tones of the sea, the quiet beach and the houses nestling at the foot of the hill.

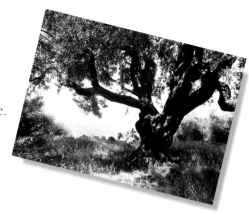

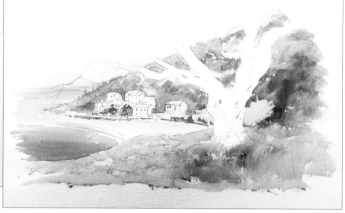

1. Draw the main outlines with a 2B pencil. Wash in the sky with cobalt blue. Wash in the sea with the medium detail brush and a mix of cobalt blue and sunlit green. Wash in the beach using raw sienna.

2. Paint in the far distant headland using a mix of pale cobalt blue and sunlit green. With a stronger mix of the same colour, paint in the hill leading down to the beach. The foreground is a warmer mix of country olive, sunlit green and burnt sienna.

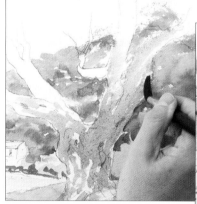

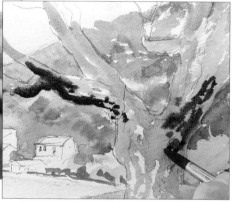

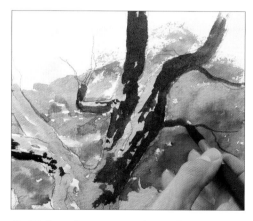

3. Paint the trunk and branches using a light mix of country olive and burnt umber.

4. Add darker areas using a mix of midnight green and burnt umber.

5. Using the same mix, paint in the darker branches.

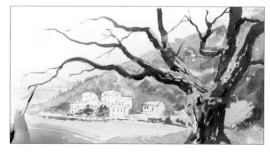

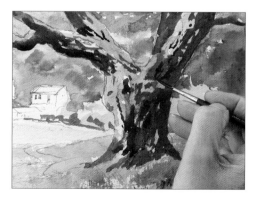

7. Add the gnarled features and detail with a mix of midnight green and burnt umber.

6. Change to the half-rigger and add the finer branches.

8. With the golden leaf brush and the lighter sunlit green, start to stipple in the foliage.

9. Change to country olive and add darker tones.

10. Keep building up the darker tones with midnight green.

11. Add finer branches using the half-rigger and a mix of burnt umber and midnight green.

12. Now, using midnight green and the fan gogh, flick grasses up at the base of the tree.

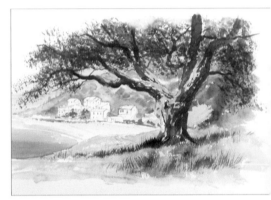

13. Add detail to the foreground grasses using the half-rigger.

The finished painting

510 x 310mm (20 x 12¼in)

Finally, lay a light wash of raw sienna over the walls of some of the buildings, with an occasional touch of alizarin crimson. Paint in the rooftops with mixes of cadmium red, cadmium yellow and touches of cobalt blue. Add touches of cadmium red, cadmium yellow and ultramarine along the edge of the beach.

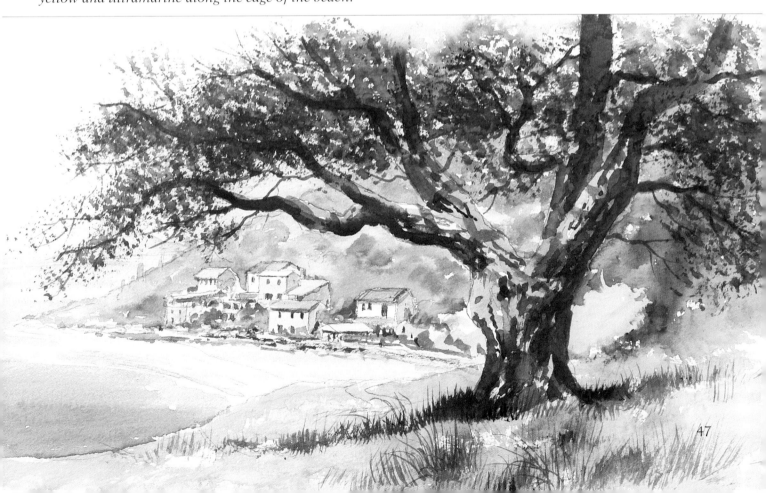

47

Index

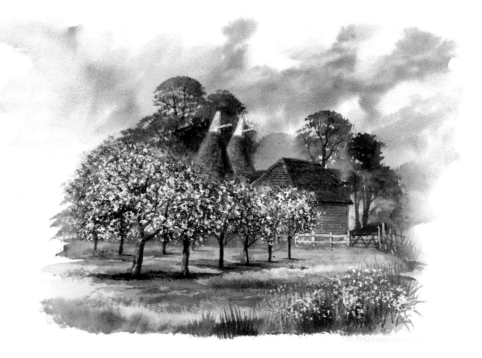

Apple blossom time

The main focus in this painting is the apple orchard which leads the eye through to the farm buildings. The background trees help to highlight the shape of the oast houses.